PRIMITIVES

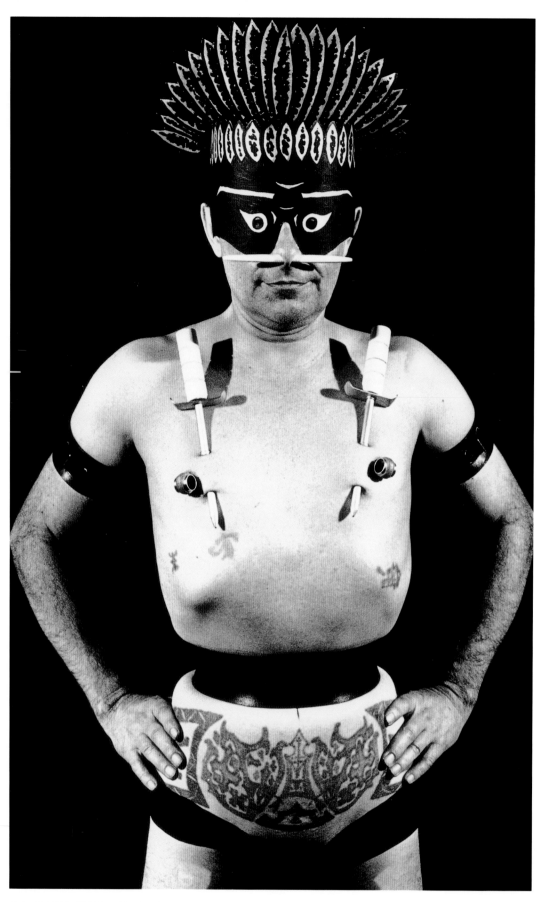

Published by Last Gasp of San Francisco, PO Box 410067, San Francisco, CA 94141

THIS BOOK IS DEDICATED TO V. VALE

PRIMITIVES

► ◄ TRIBAL BODY ART
► ◄ AND THE
► ◄ LEFT-HAND PATH

CHARLES
GATEWOOD

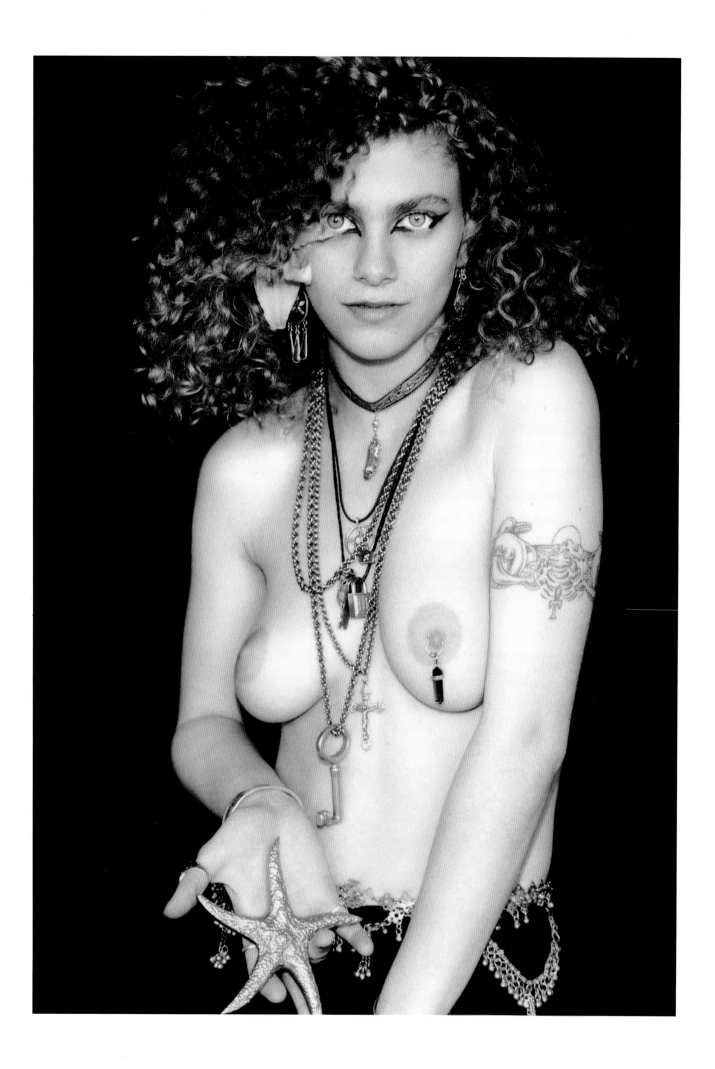

INTRODUCTION

People often ask why I've spent the past twenty-five years studying and photographing body modification. They express doubt that tattooing, piercing and modern primitive lifestyles should be considered *important*. One photographer friend even lectured me, saying my early photojournalistic street photography was "so much more vital." He was sad, he confided: I was wasting my talent, and he feared I'd *lost my path.*

On the contrary, I have *found* my path, the left-hand path, the path through the woods, and I am walking it with wonder, delight and clear-eyed fascination. This most amazing journey to the heart of neo-tribal body adornment has not only changed my consciousness and lifestyle, but indeed my entire being. And the Re/Search book *Modern Primitives*, which I helped inspire and create, has changed the thinking and behavior of an entire generation of seekers. How's that for "vital?"

You hear your music, say the Sufi Masters, *and you fall in line.* Recognizing something older and deeper than yourself, you enter sacred space, a world of magical transformation – and immediately you know your life will never be the same. Body art can be equally seductive, yet the journey can be dark and dangerous. Friends, family, employers may not approve or understand. So?

Do you hear the music? Will you join the dance?

<div align="right">

Charles Gatewood
San Francisco
Sun in Scorpio, 2001

</div>

AWAKENING

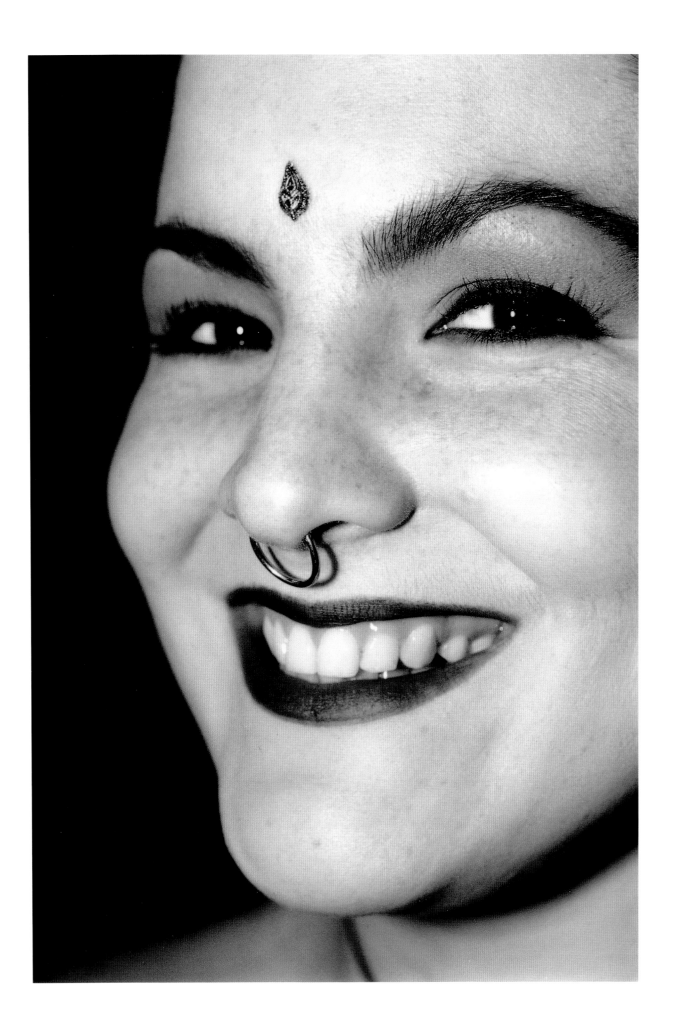

IMAGINE

WE ARE BORN FREE YET WE LIVE IN CHAINS. ALIENATED AND NUMBED BY THE DYSFUNCTIONAL MYTHS OF A TELEVISION CULTURE, WE HAVE LOST OUR WAY IN A MAZE OF INVOLUNTARY CONDITIONING.

TO ESCAPE, RECONNECT AND HEAL WE MUST REDEFINE REAL AND POSSIBLE. IN SO DOING WE LOOK TO ANCIENT SOURCES FOR "PRIMITIVE" ANSWERS.

OUR DREAM IS A WORLD OF HARMONY AND BALANCE, A WORLD RICH IN LOVE AND SPIRIT, A JOYOUS WORLD WHERE INTREPID VISIONARIES DREAM THE IMPOSSIBLE AS WE/YOU/THEY EXPLORE THE OUTER LIMITS OF RITUAL ART AND ECSTATIC BODY PLAY.

IMAGINE . . .

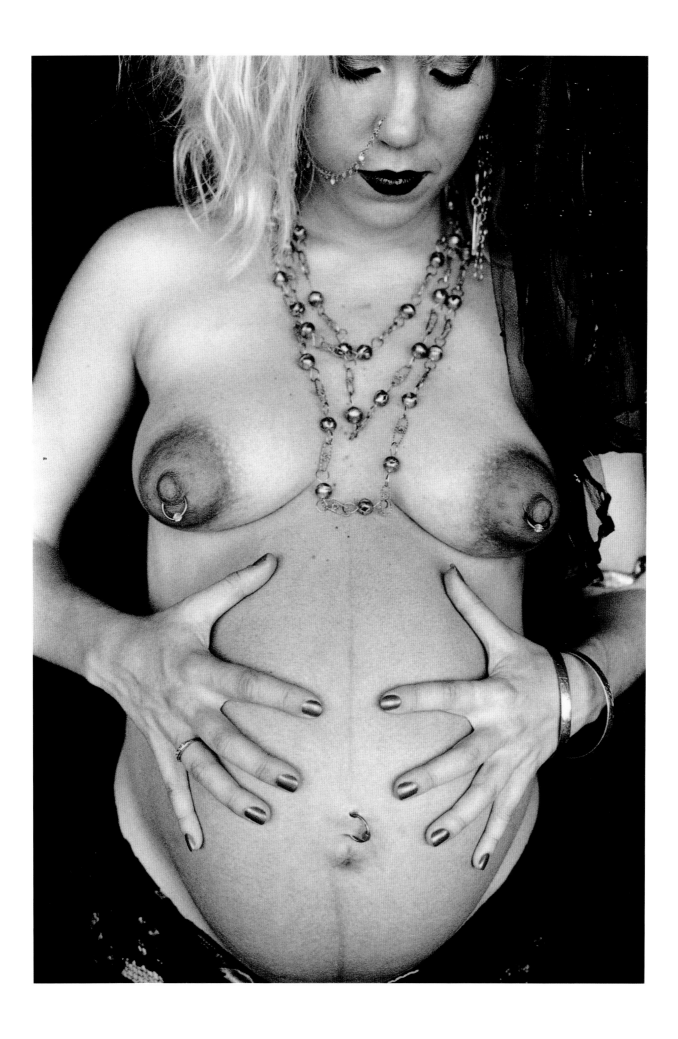

THE SLEEP OF REASON

Our so-called rational minds have been infected by programs of calculated control. Many layers of unhealthy conditioning must be scrubbed away before any real work can begin.

Body work sharpens our senses as it cleanses our psyches. Body play encourages the integration of the left brain's one-dimensional mechanics with the holistic and poetic awareness of the brain's right hemisphere.

Through such fantastic work and play we leave the world of reason to explore flashes of deeper, more intuitive knowledge in that twilight world joining physical and psychic, until our knowing springs from a more ancient source: our entire being.

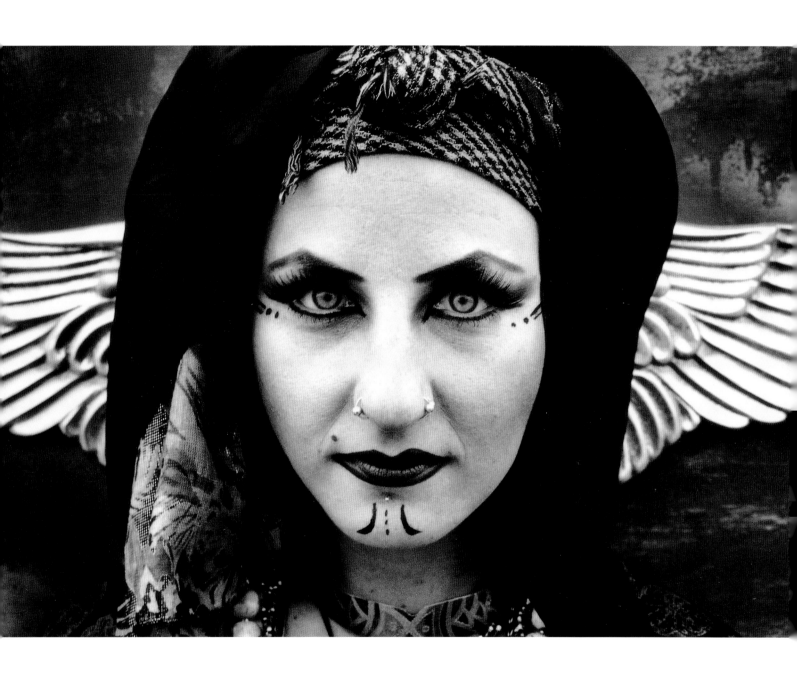

▷ Rub Out the Word ◁

Our most insidious prisons are built of words. The act of naming can separate us from immediate truths, creating a false sense of self and fostering illusions of alienation and separateness.

As primitives we respect words but we pledge no allegiance to word-locks. Instead we trust the power of symbolic action to increase awareness of our deeper selves as we strive to experience the world directly.

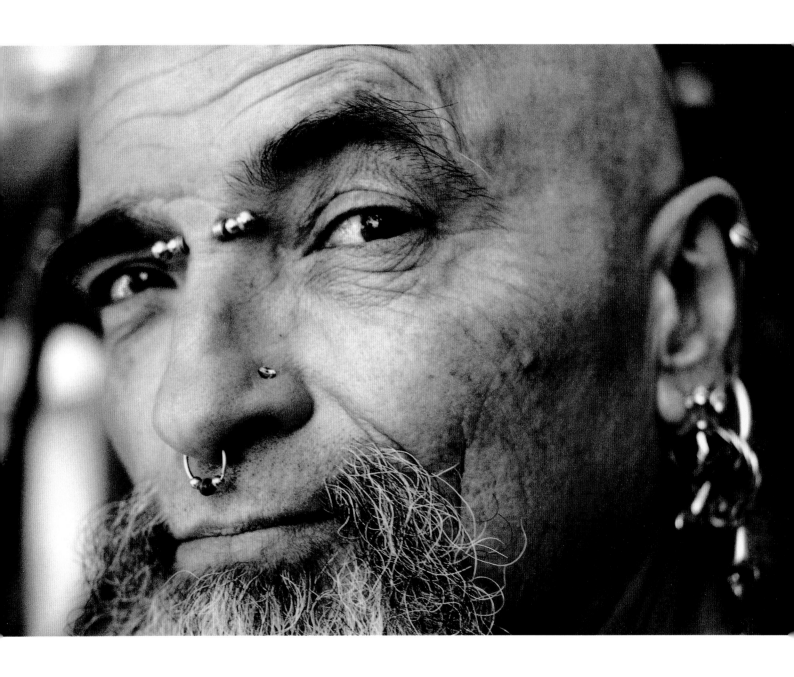

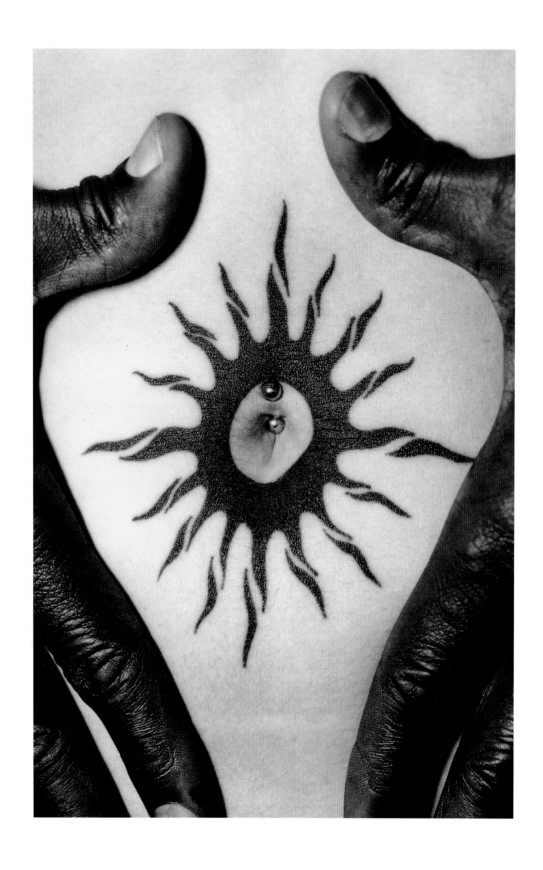

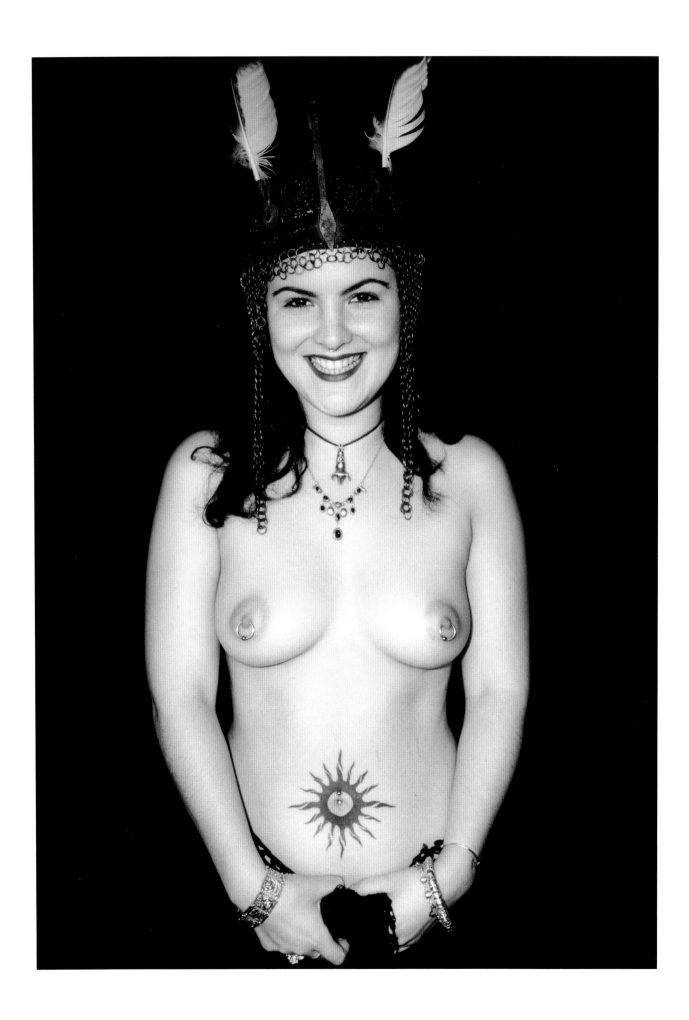

DEPROGRAMMING

MUCH OF WHAT WE "KNOW" IS NOT TRUE AT ALL. AS WE BEGIN TO SEE THE WORLD DIRECTLY THE LIES BECOME OBVIOUS. TOGETHER, THEN, WE REAFFIRM OUR INDIVIDUALITY WHILE RECLAIMING THE RIGHT TO DECIDE FOR OURSELVES EXACTLY WHAT IS TRUE AND IMPORTANT IN OUR LIVES.

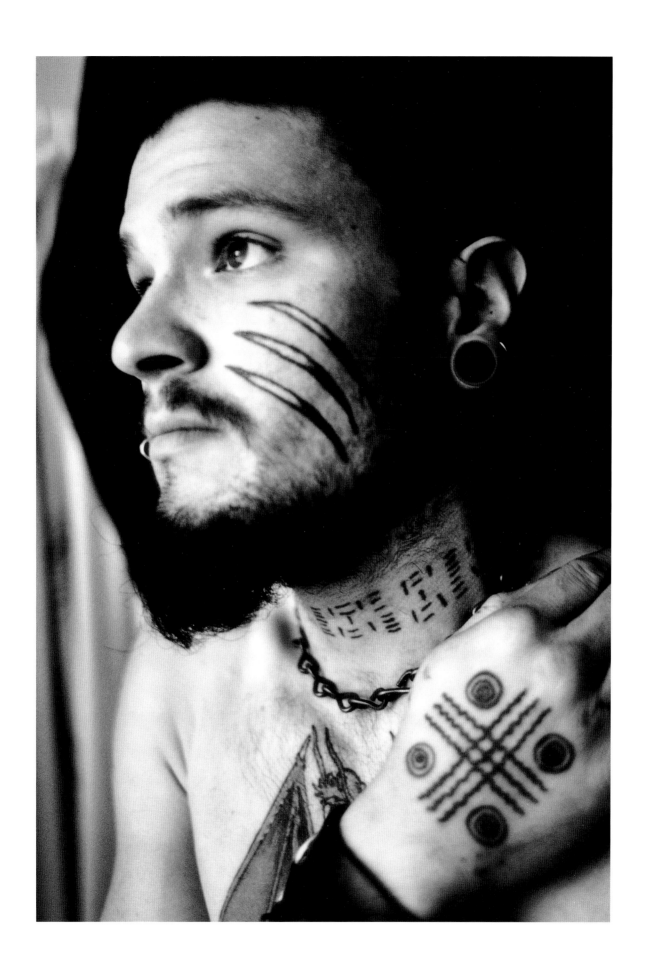

17

RECLAIMING

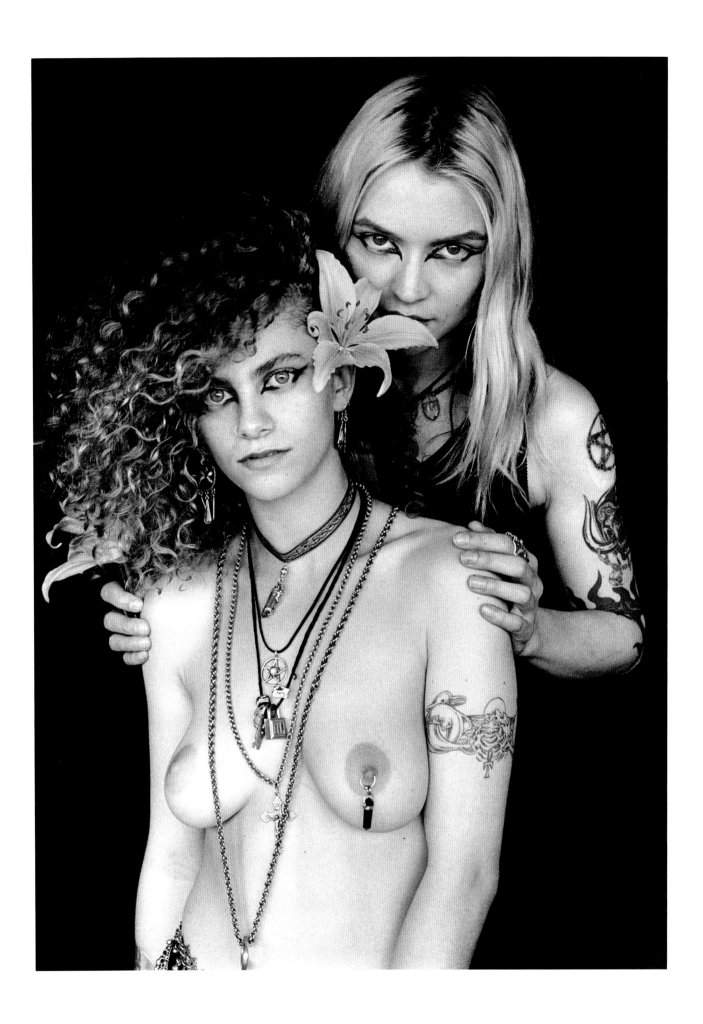

▷ A Feast of Fools ◁

We welcome a rebirth of festivity, blessed with innocence, unbound by everyday rules, where we may freely pursue wondrous sources of creative inspiration. By actualizing entire fantastic worlds we exercise the greatest gift of all: the joyous expression of unfettered imagination.

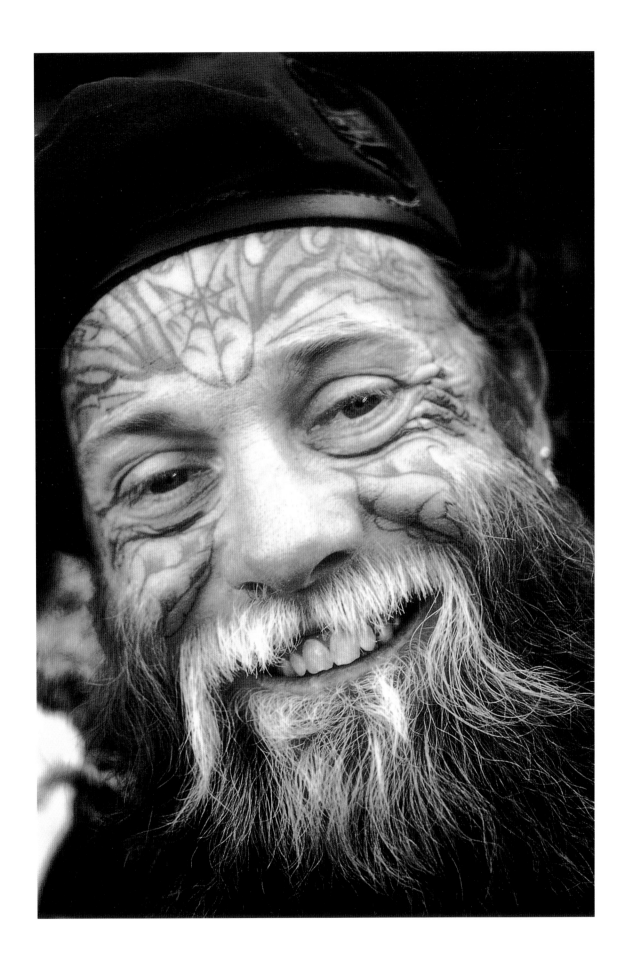

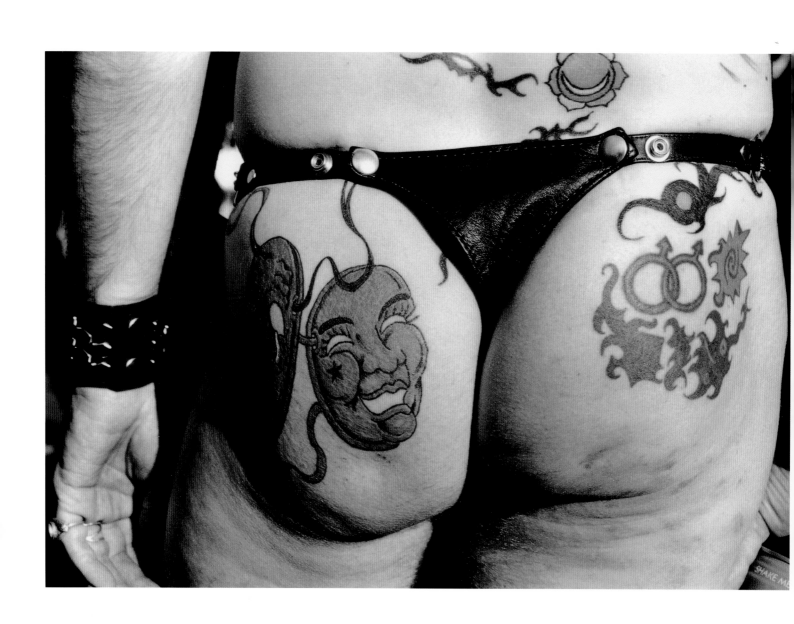

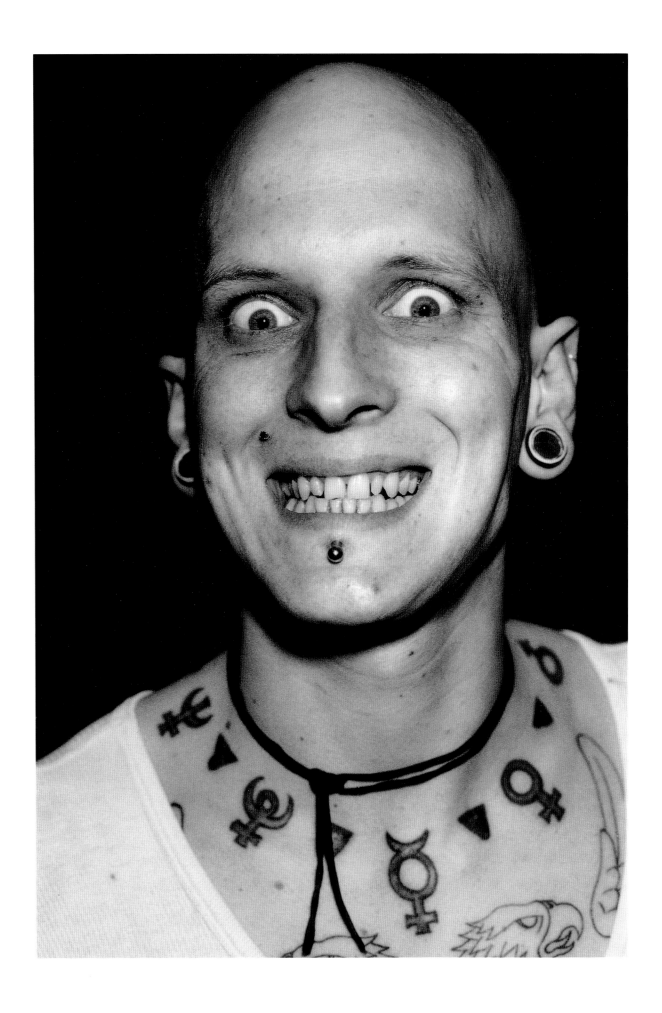

▷ SACRED TIME ◁

INDUSTRIAL TIME — LINEAR, ARTIFICIAL AND MECH— ANICAL — CHANGES OUR NATURAL RHYTHMS, ALIENATING US FROM OURSELVES AND NATURE. TO RECONNECT WITH SACRED TIME WE EXPLORE THE WORLDS OF VISIONARY PLAY.

SACRED TIME EXISTS IN THE HARMONIC FLOW OF HERE AND NOW. WE HAVE ALL EXPERIENCED SUCH MAGICAL MOMENTS, BEYOND CLOCKS, BEYOND NUMBERS. WE TREASURE THESE PLAYFUL PEAKS, FOR THEY FACILITATE ECSTATIC FLOW.

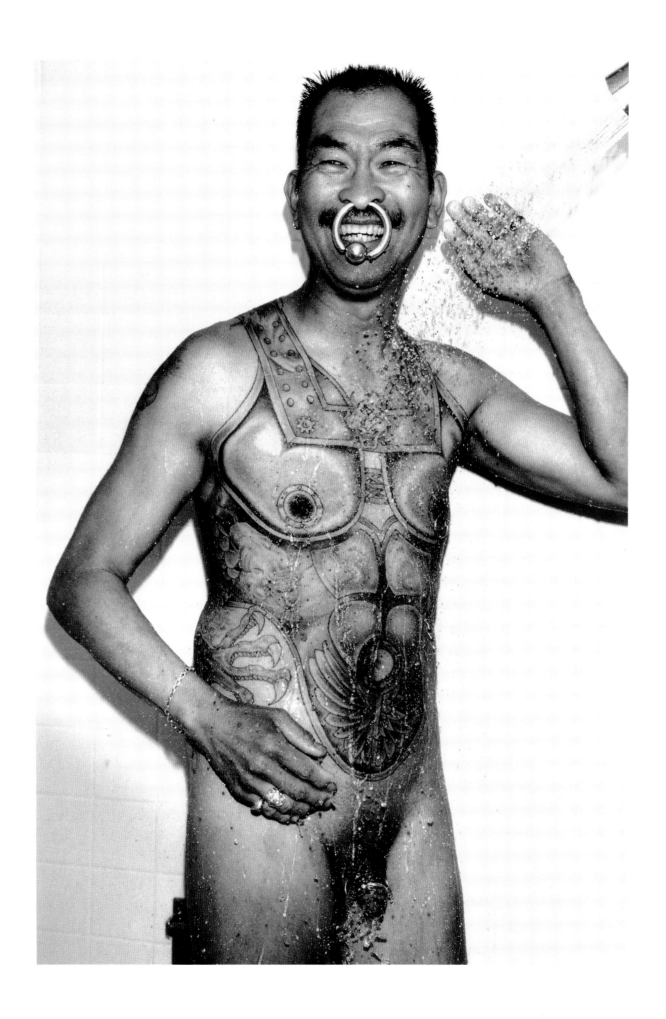

BODY PLAY

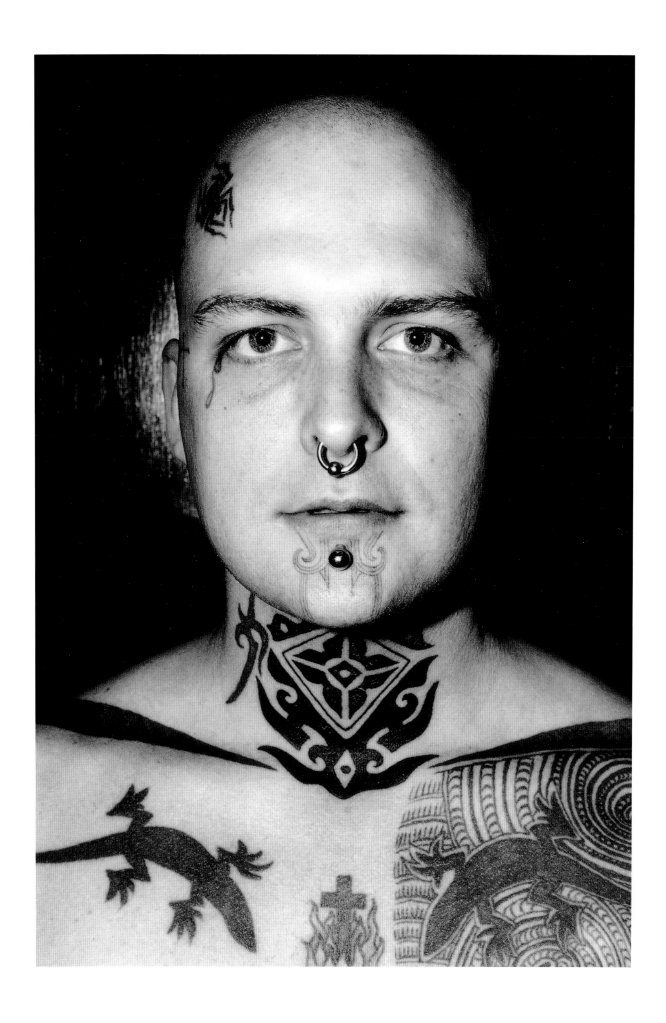

▷ Tattoo Magic ◁

True art has always been a magical reordering of reality, evoking deep primal energies. Most contemporary art has lost this sacred context, existing as decoration, commodity or status symbol.

Ritual tattooing reconnects us with the power of those deep and ancient sources. As we celebrate the fusion of fantasy with the deeper symbolism of the universal unconscious, we externalize a meta-physical part of our primal selves. The resulting form speaks with an authority that is clear, bold and unmistakably authentic.

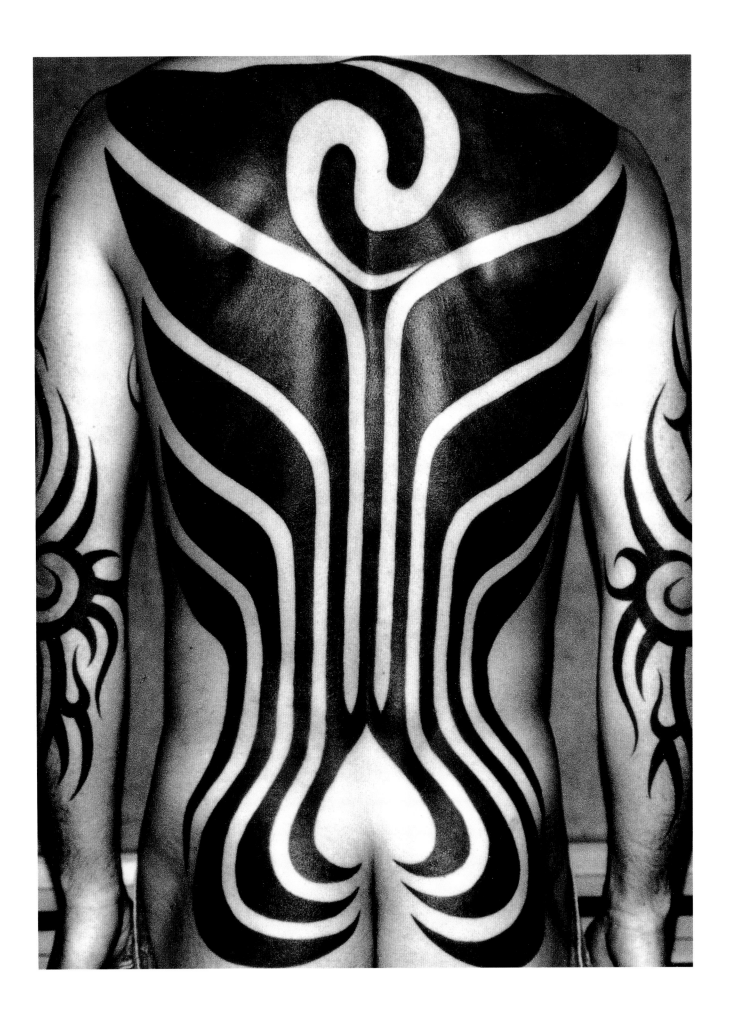

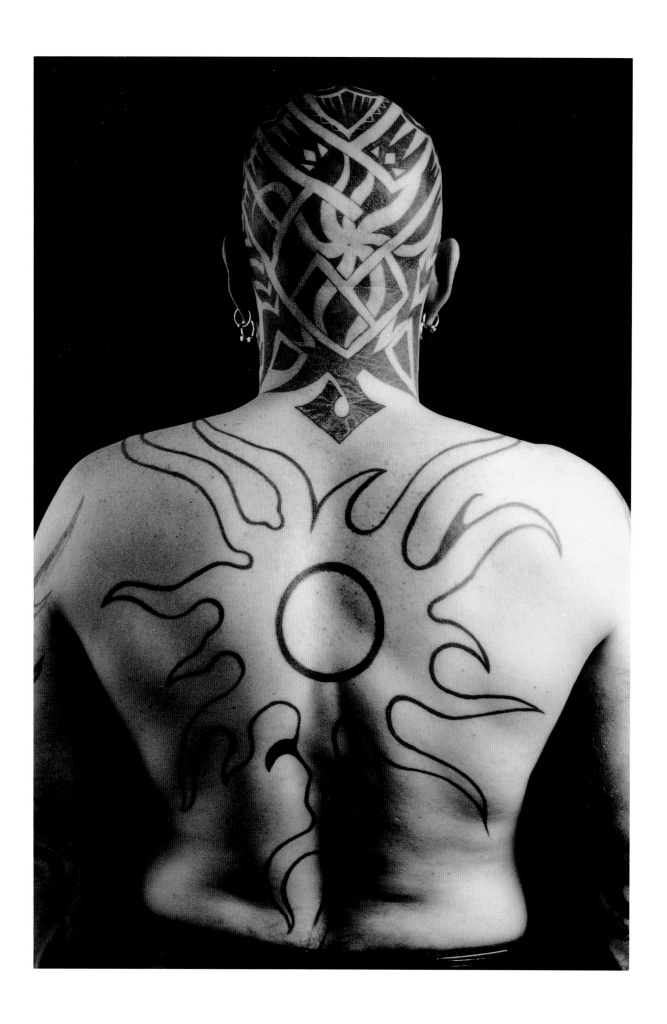

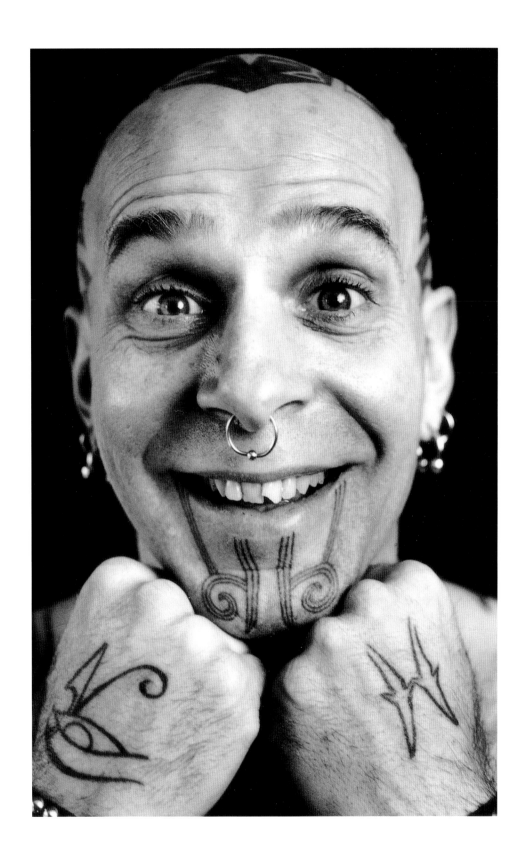

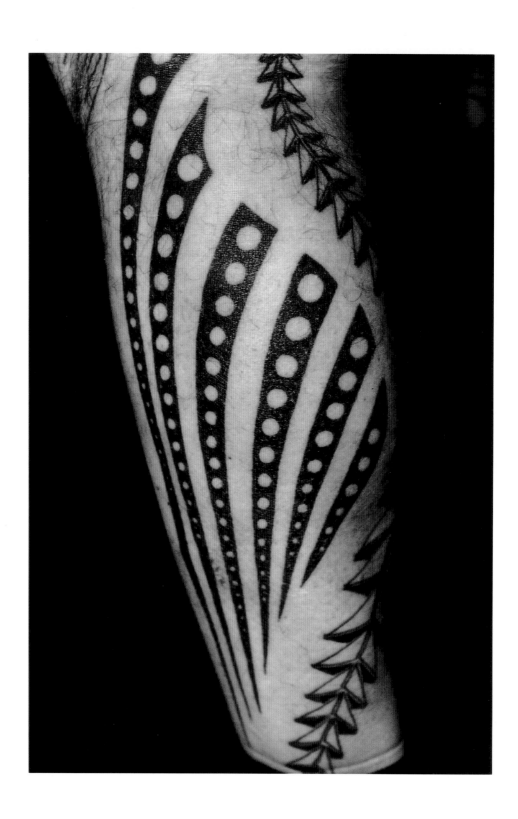

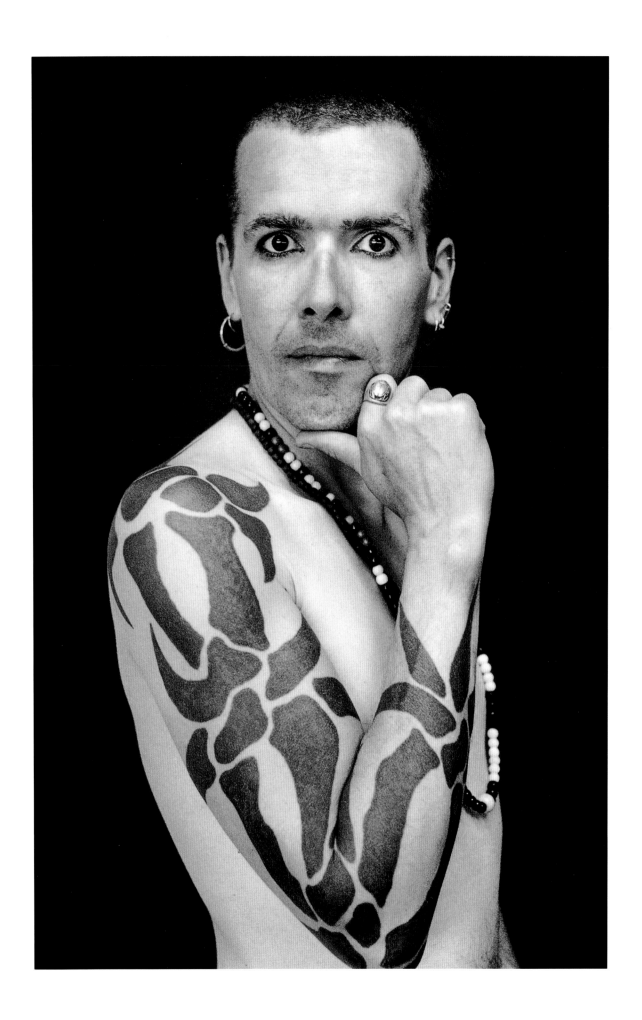

Do As We Will

WE SEEK TO REAWAKEN OUR ATROPHIED SENSES ANY WAY WE CAN, PUSHING ALL PHYSICAL LIMITS IN SEARCH OF CONSCIOUS UNION. STIMULATED BY AESTHETIC SHOCKS, OUR MINDS AND BODIES ACQUIRE SUPRAHUMAN POWERS, ALLOWING US TO CHANGE OUR CONSCIOUSNESS AT WILL.

THIS IS TRUE MAGIC.

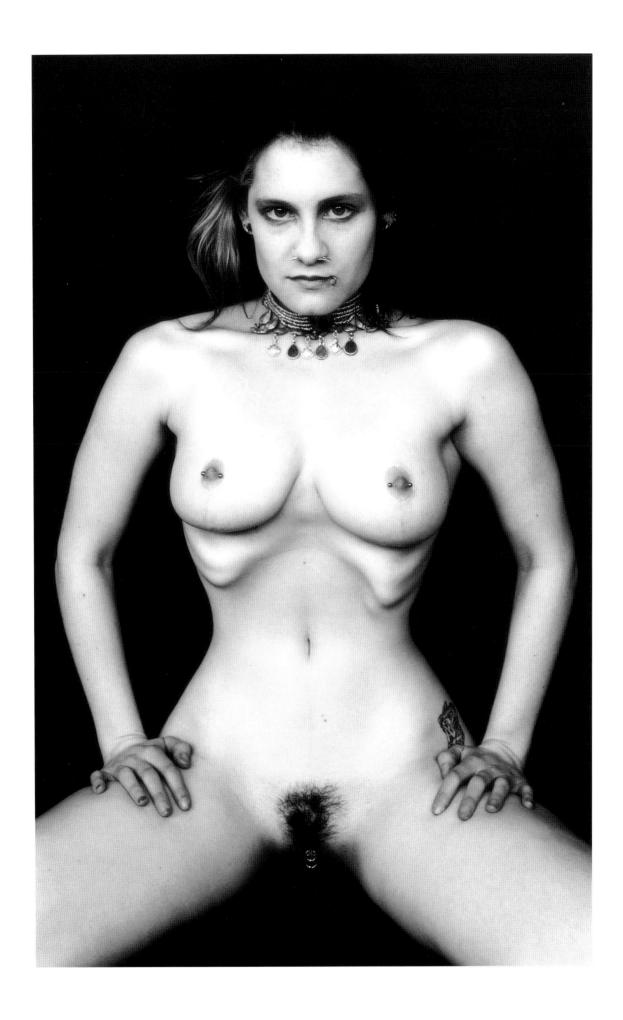

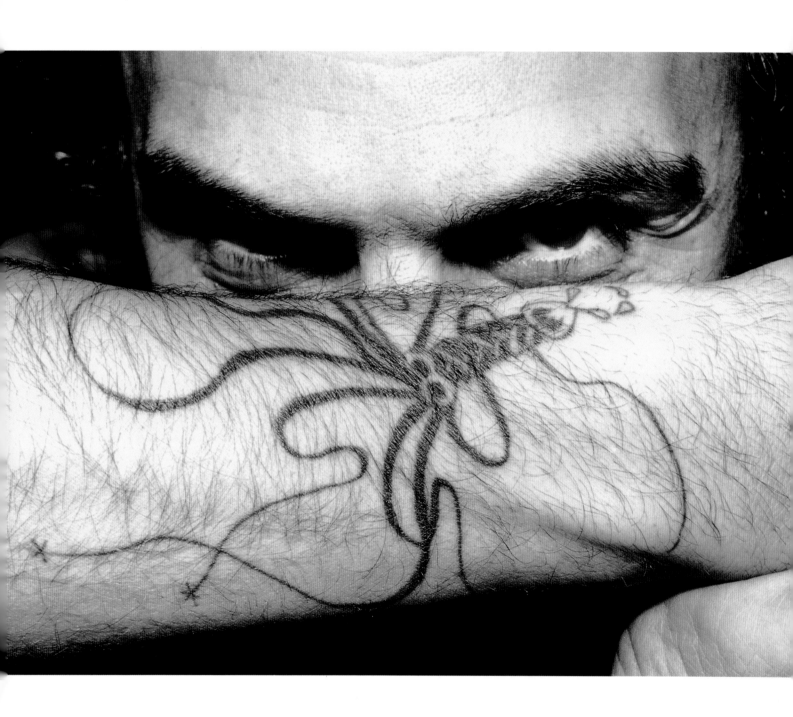

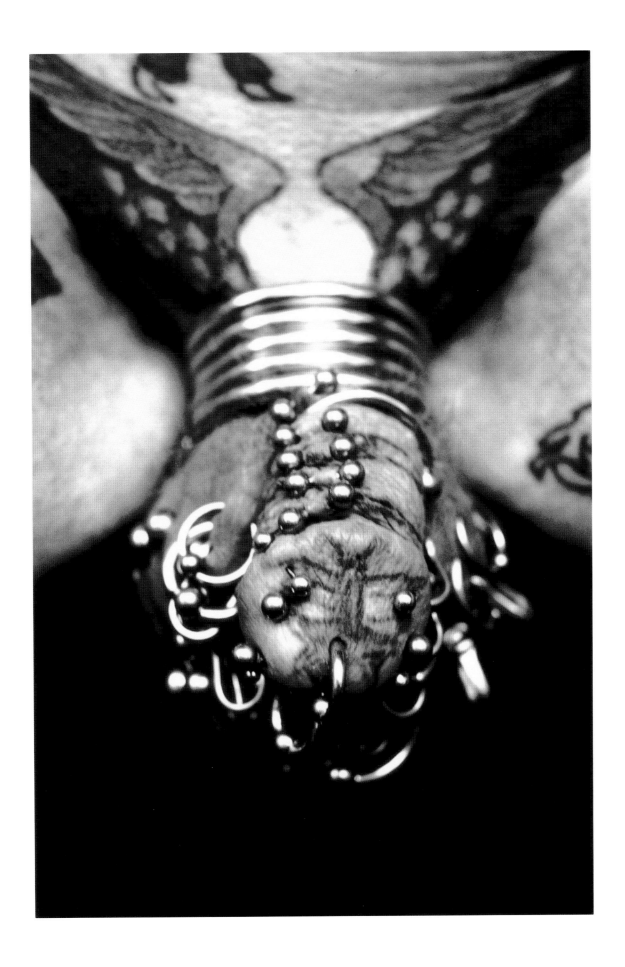

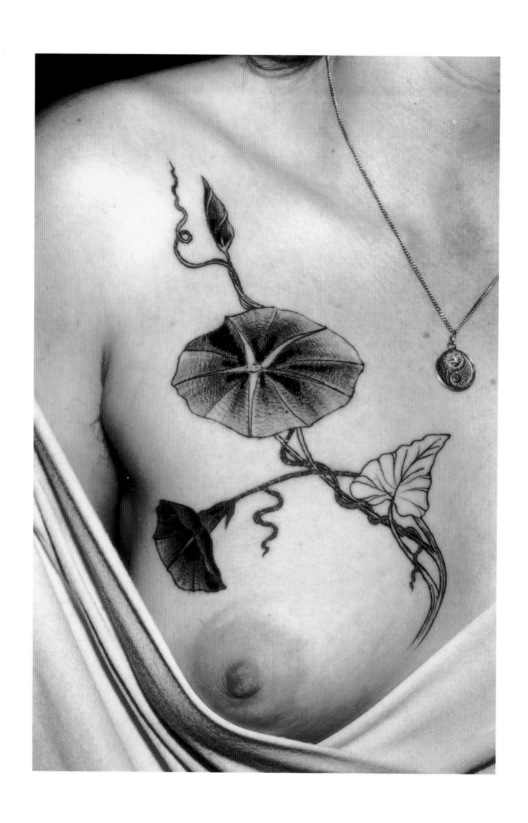

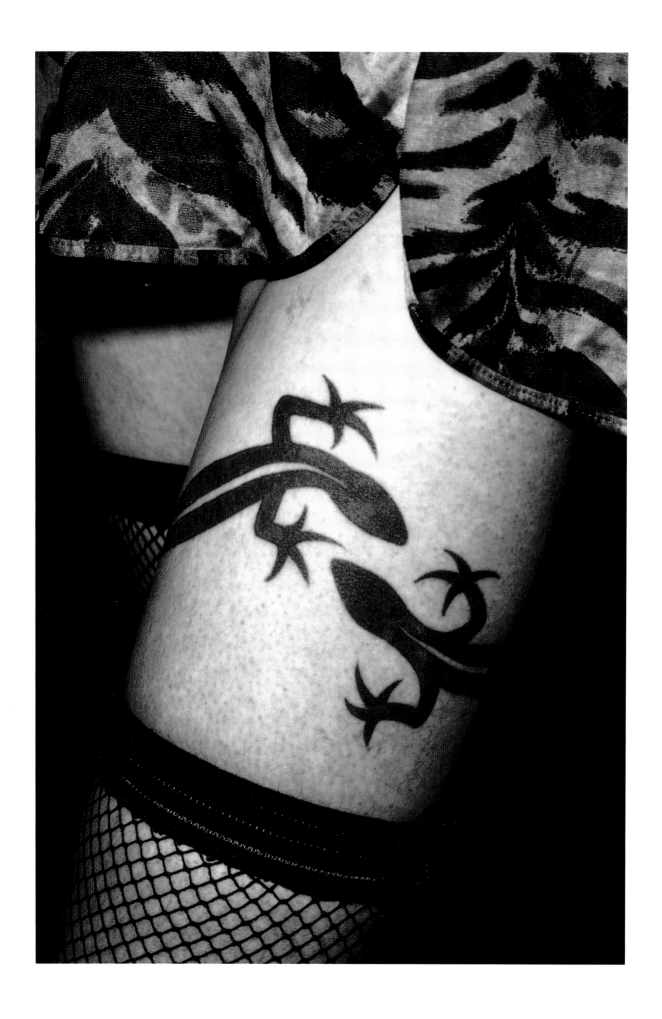

RITUAL WOUNDING

▷ ◁

In tribal societies initiation into adulthood involves a ritual separation from parents, often followed by the gift of a symbolic wound. Through this new opening we glimpse painful vulnerabilities as well as unfathomed strengths.

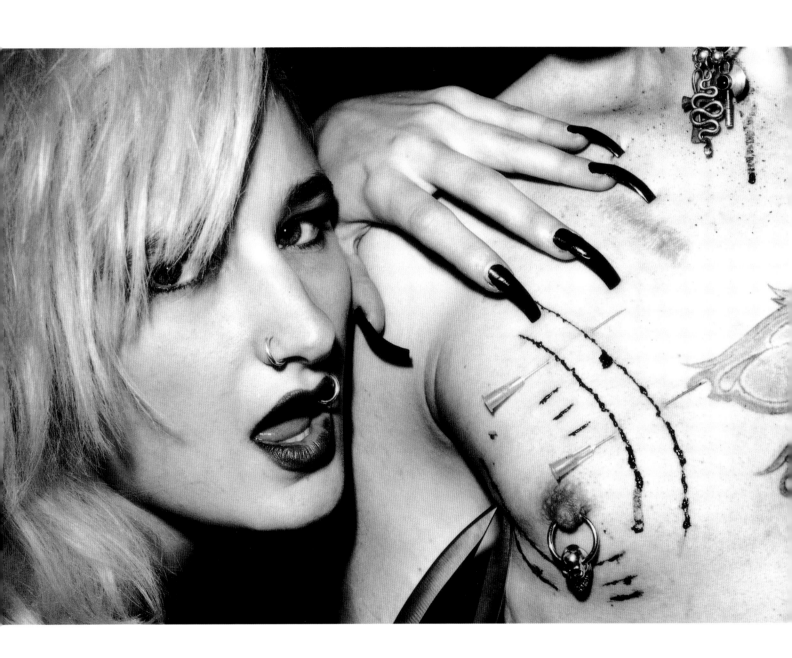

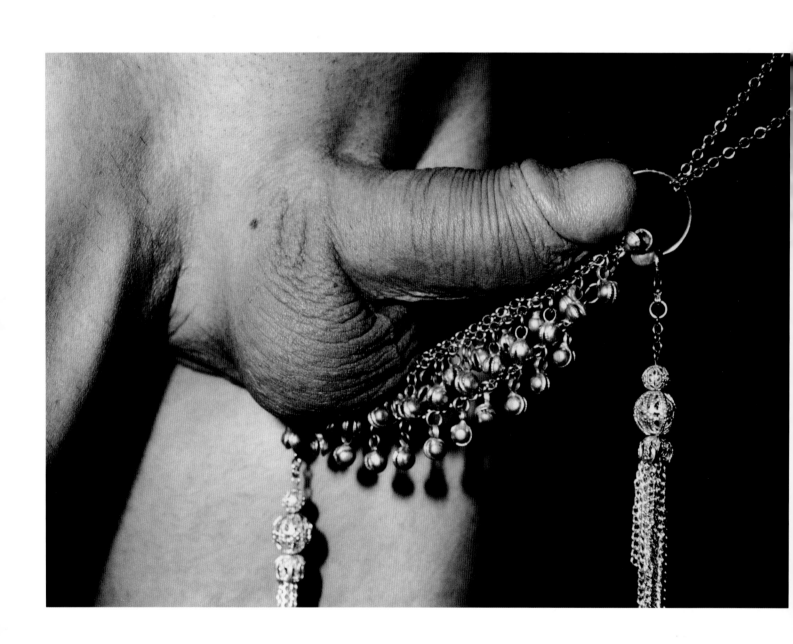

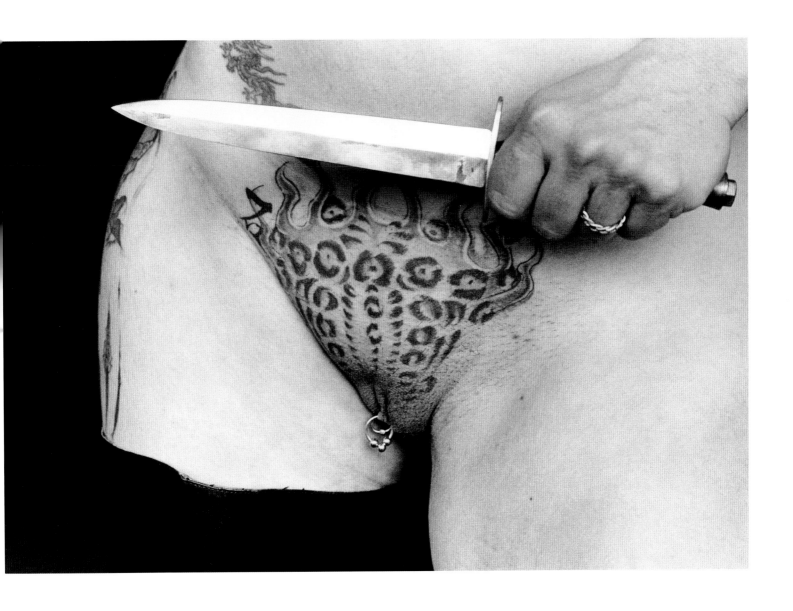

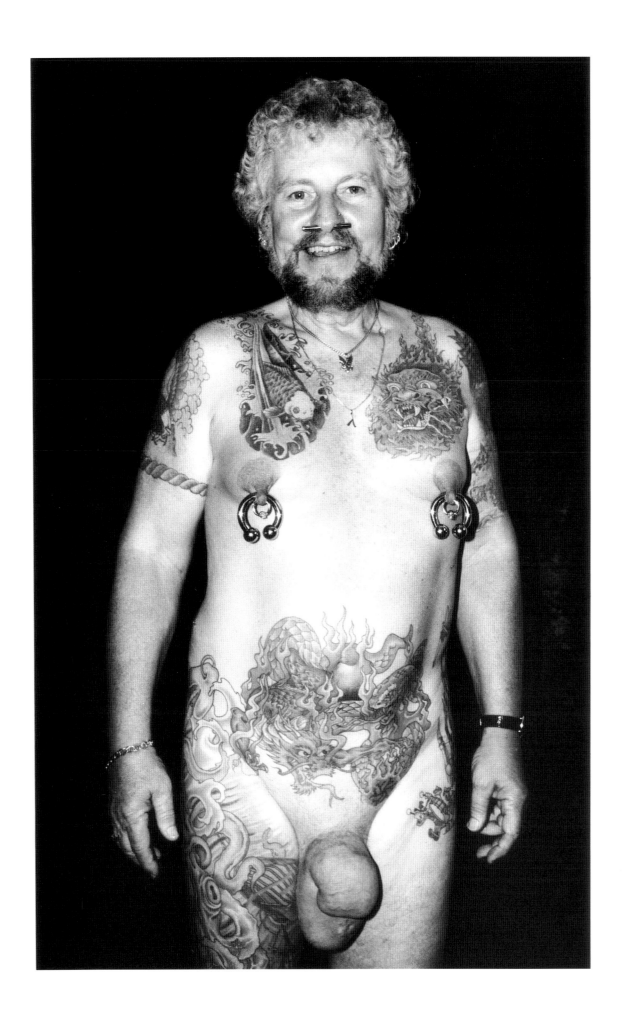

❦HEALING

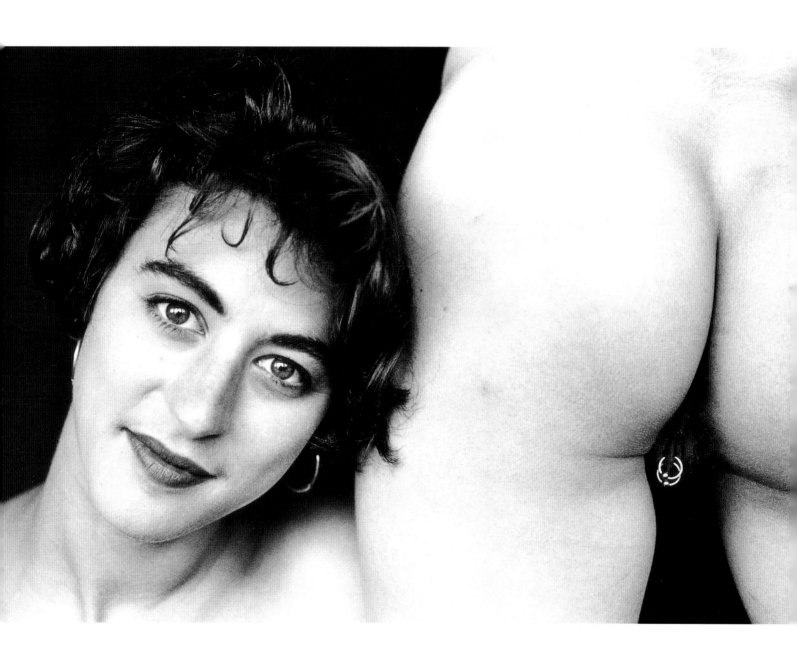

▷ Recovering ◁

Our left-hand path honors darkness as well as light. To heal, to grow and to resist future dependence we embrace the full range of experience and emotion. Darkness denied can devour. Darkness projected can destroy. Darkness affirmed can nurture healthy transformation.

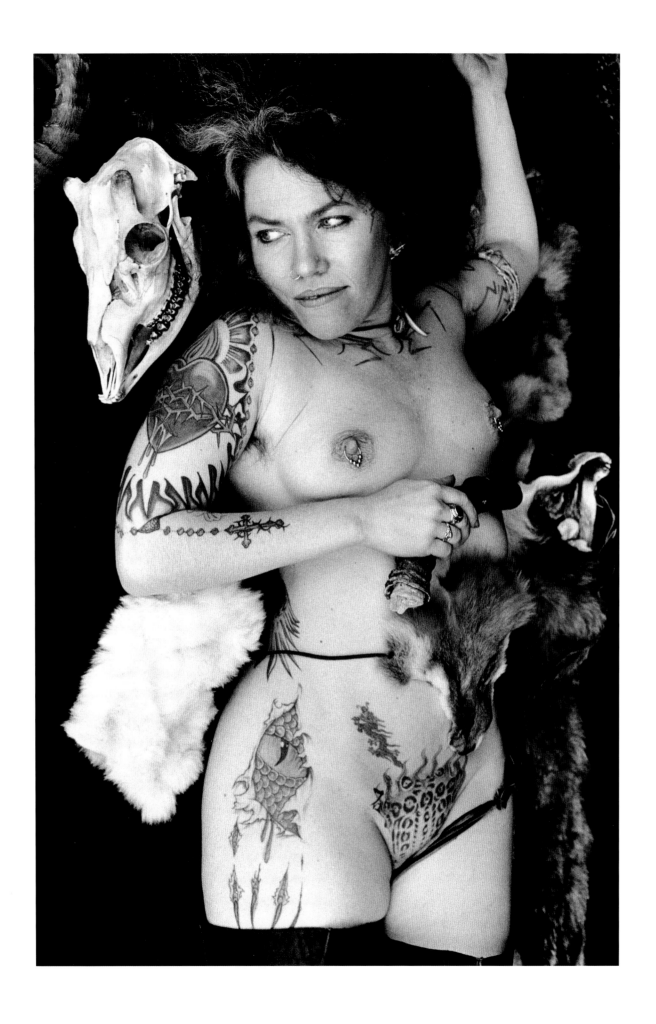

▷ INTEGRATING ◁

At last.

Mind, body and spirit are one.

Dark and light are balanced.

We are whole.

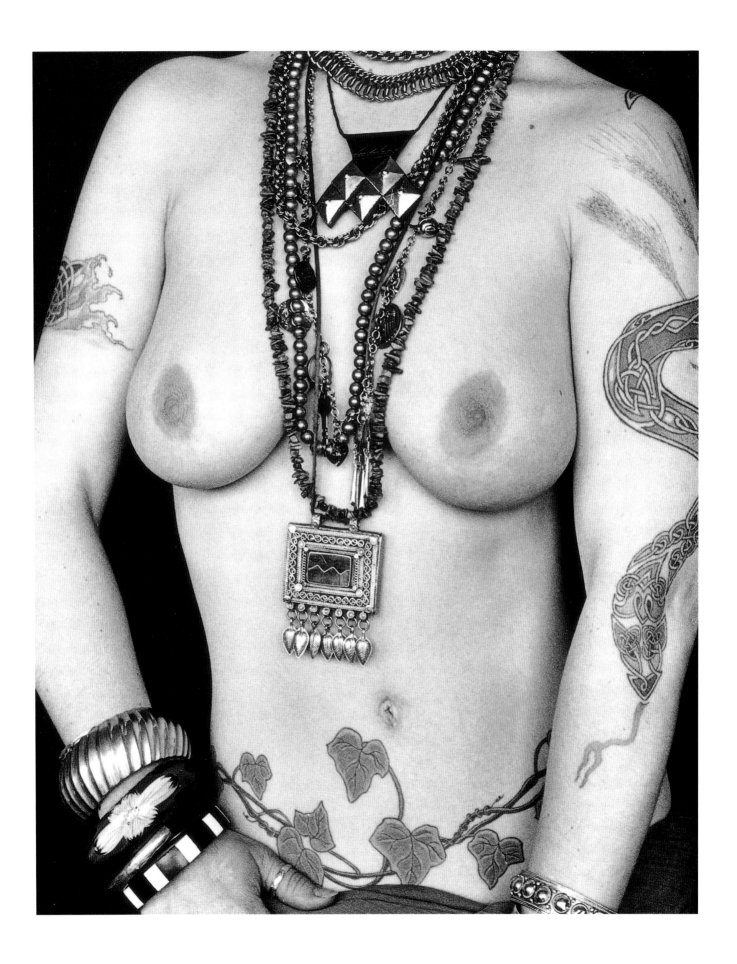

SOARING

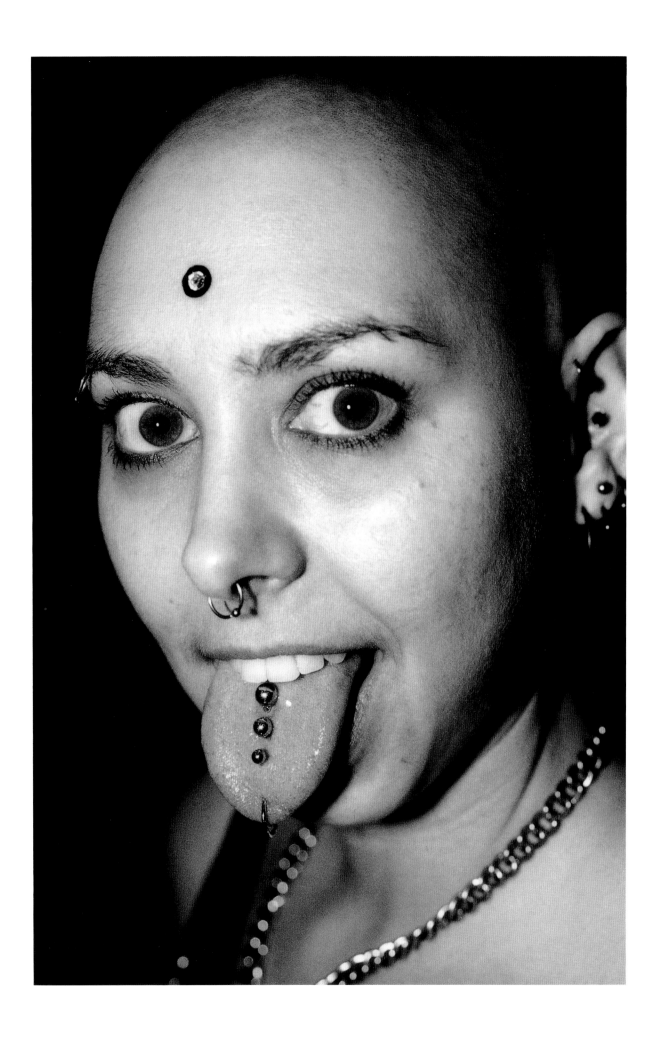

▷ COMMUNION ◁

UNION.

CONNECTEDNESS.

WELCOME HOME.

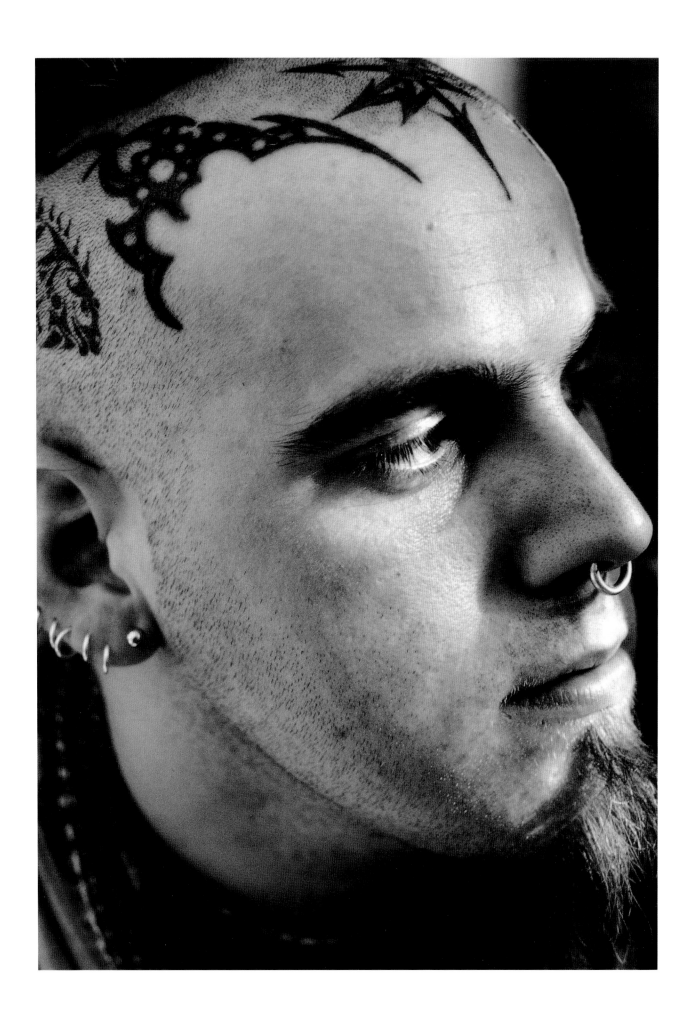

▷ OUT THERE ◁

WE ARE FREE AT LAST.

THERE ARE NO LIMITS.

IMAGINE . . .

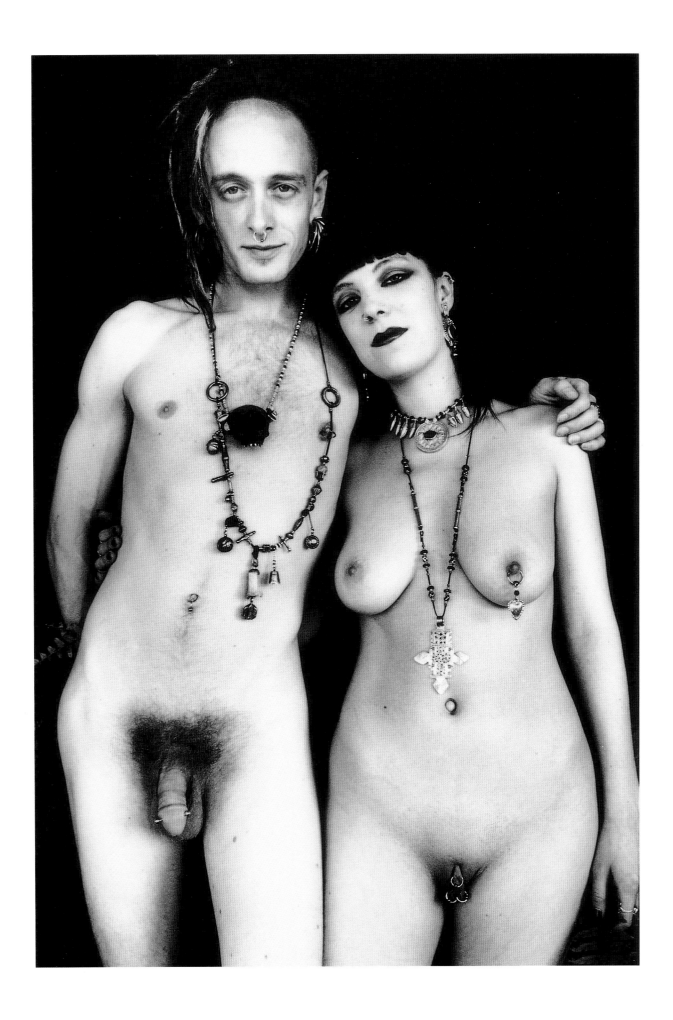

LOVE IS OUR MESSAGE

NOTHING IS TRUE.

EVERYTHING IS PERMITTED.

BLESSED BE!

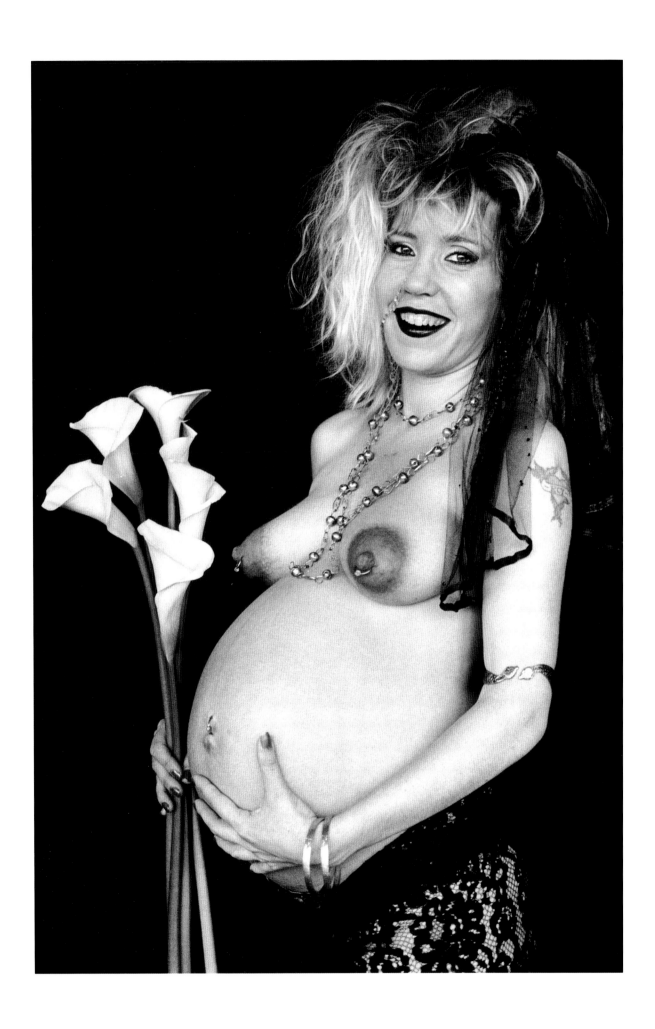

✿ARTISTS AND MODELS

Cover	DJ Polywog, tattooed by Joe Leonard (left arm) and G. Cosmo (right arm).
Page 2	Bubbles, tattooed by Jaime Trujillo, pierced by Susan and Big Ed.
Page 4	Fakir Musafar, tattooed by himself and by Davy Jones, pierced by himself.
Page 7	Vita McConnell, septum piercing by Marc.
Page 9	Daisy Anarchy, nipples pierced by Raelyn Gallina, navel pierced by Karen Hurt/Gauntlet.
Page 11	Carmen Lee, pierced by Nalla and Zeke.
Page 13	Earl Van Aken, pierced by Gauntlet.
Page 14, 15	Vita McConnell, navel tattoo by Gumby, piercings by Gauntlet.
Page 17	Brad Roberts, tattooed by John H. (face), Anthony (neck) and Ike (chest), pierced by Scott Childress.
Page 19	Bubbles with Angel Starr, who was tattooed by Alaska Mike.
Page 21	Gordon "Face," tattooed by "Doc" Don Anderson.
Page 22	Daddy Bear/Rings, tattooed by Mad Dog.
Page 23	Alex Binnie, tattoos and labrette piercing by Mr. Sebastian, "Madonna: piercing by Elayne Binnie, stretched ear piercings by himself.
Page 27	Ron Athey, Moko tattoo by Jill Jordan, sacred heart and face tattoos by Bob Roberts, throat tattoo by Alex Binnie, small throat tattoo and lizards by Leo Zulueta. Labrette piercing by Crystal Cross, other piercings by Brian Murphy/ Gauntlet.
Page 29	Kirk, tattooed by Leo Zulueta
Page 30-31	Mr. Moko, tattooed by Pat Sinatra (head and back), Dan Thomé (left hand and chin), and Paul Ortloff (right hand), pierced by Pat Sinatra.
Page 32	Roger Kaufman, tattooed by Kat.
Page 33	Michael Wilson, tattooed by Fineline Mike (face) and Pat Martynuik/Picture Machine.
Page 34	Angel Starr, tattooed by Alaska Mike.
Page 35	Kevin Joy, tattooed by Greg Kulz
Page 37	Michaela Grey, tattooed by Darren Rosa, pierced by herself and by Jim Ward (septum and clitoral hood piercing #1), Kristen Borges (nostril and clitoral hood piercing #2) and Scott Shatsky (lip and nipples).
Page 38	Marco Vassi, tattooed by Spider Webb.
Page 39	Sailor Sid, tattooed by Cliff Raven and Mr. Sebastian, pierced by himself, Mr. Sebastian, and Jack Yount.
Page 40	Myra Fourwinds, tattooed by Vyvyn Lazonga.
Page 41	Sharee, tattooed by Leo Zalueta
Page 43	Lily Braindrop, pierced by herself and Esther Saldana/Body Manipulations; Michael Decker, tattooed by Jill Jordan, pierced by Elayne Binnie, chest scar by Sheila Wells, cuttings and play piercings by Lily Braindrop.
Page 44	Erich Sweet, tattooed by Dan Thomé.
Page 45	Rita Daley, tattooed by Fred Corbin, pierced by Gauntlet and Vaughn/Body Manipulations.
Page 46	Jim Kallett, tattooed by Dan Thomé.
Page 47	Jack Yount, tattooed by Ed Hardy (necklace) and Fred Corbin, pierced by Vaughn/ Body Manipulations, Gauntlet and Slave Ken.
Page 53	Theresa Dutton, tattooed by Bill Salmon (snake, ivy) and Vyvyn Lazonga.
Page 55	Elayne Binnie, pierced by Gauntlet and herself.
Page 57	Scott Childress, tattooed by Andre, Brian and Dave, pierced by himself
Page 59	Keath Briley, pierced by Karen/Body Manipulations and Gregorio Goss/Body Adornments (ampallang); Susan Tobiason, pierced by Keath Briley and Gregorio Goss/ Body Adornments.
Page 61	Daisy Anarchy, pierced by Raelyn Gallina and Karen Hurt/Gauntlet.

✿THANK YOU!